Colorie-moi sengiousement

Colour Me Whimsical

Beverly Pearl

ISBN: 978-1-329-38139-1

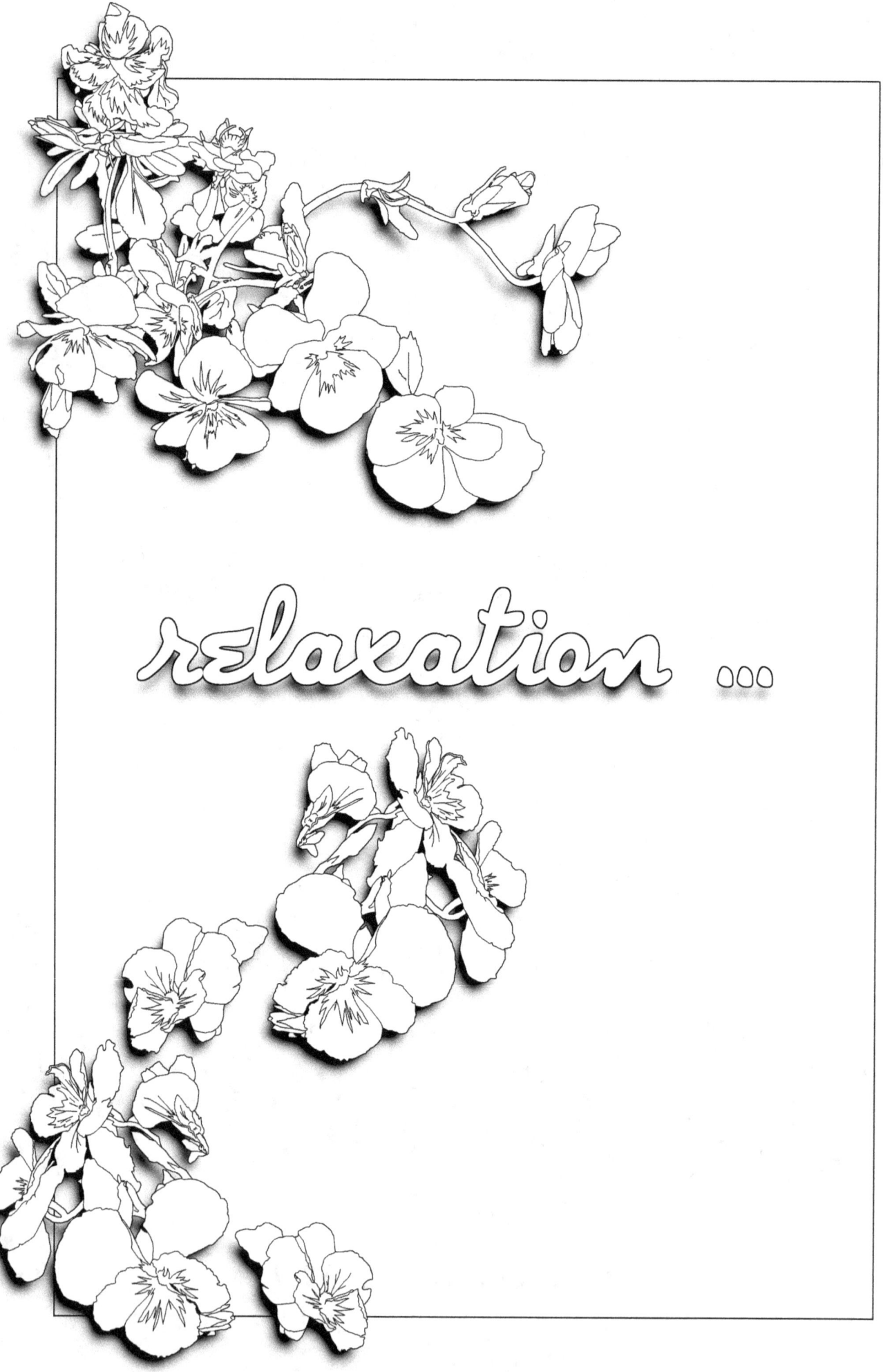

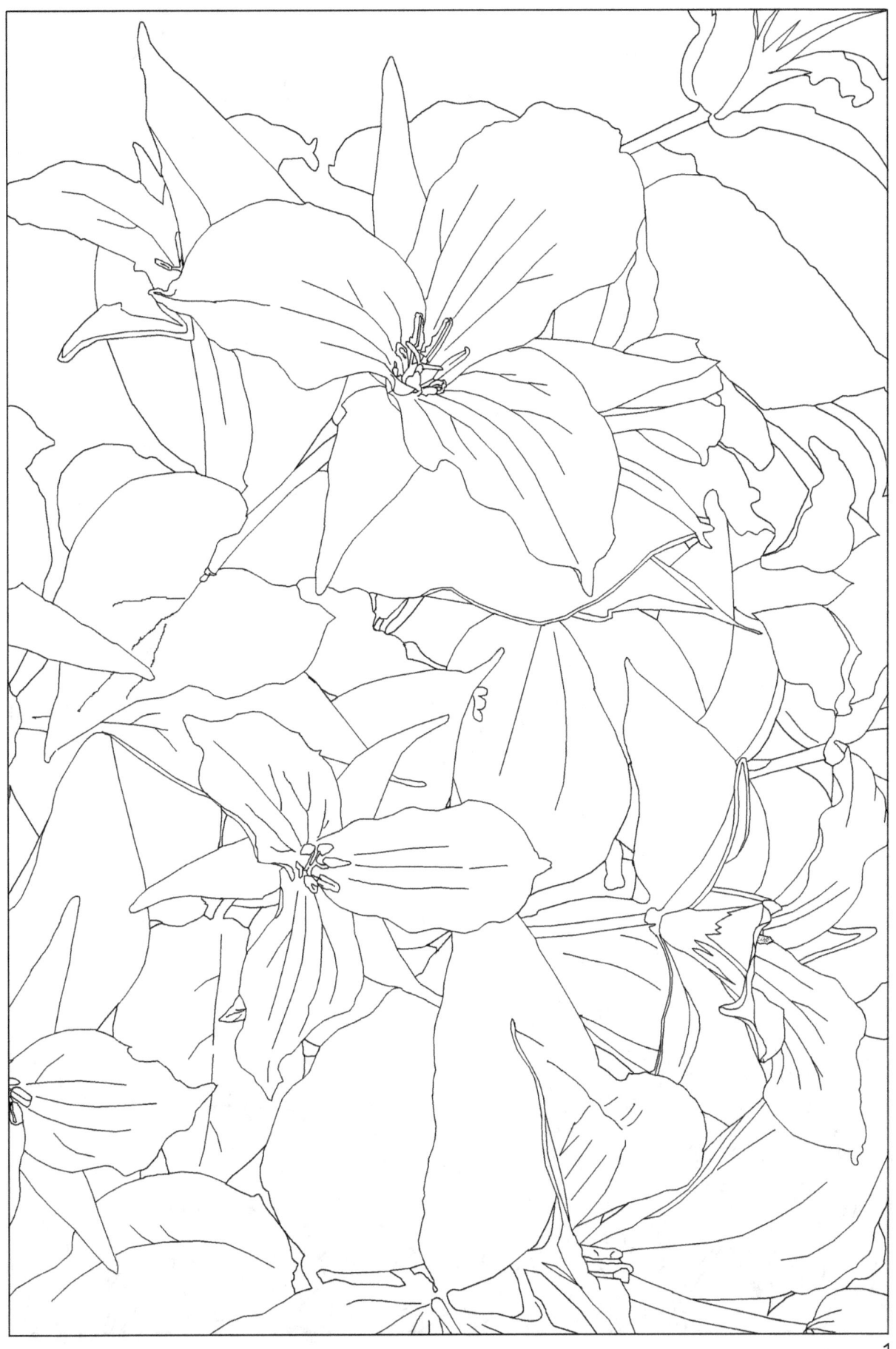

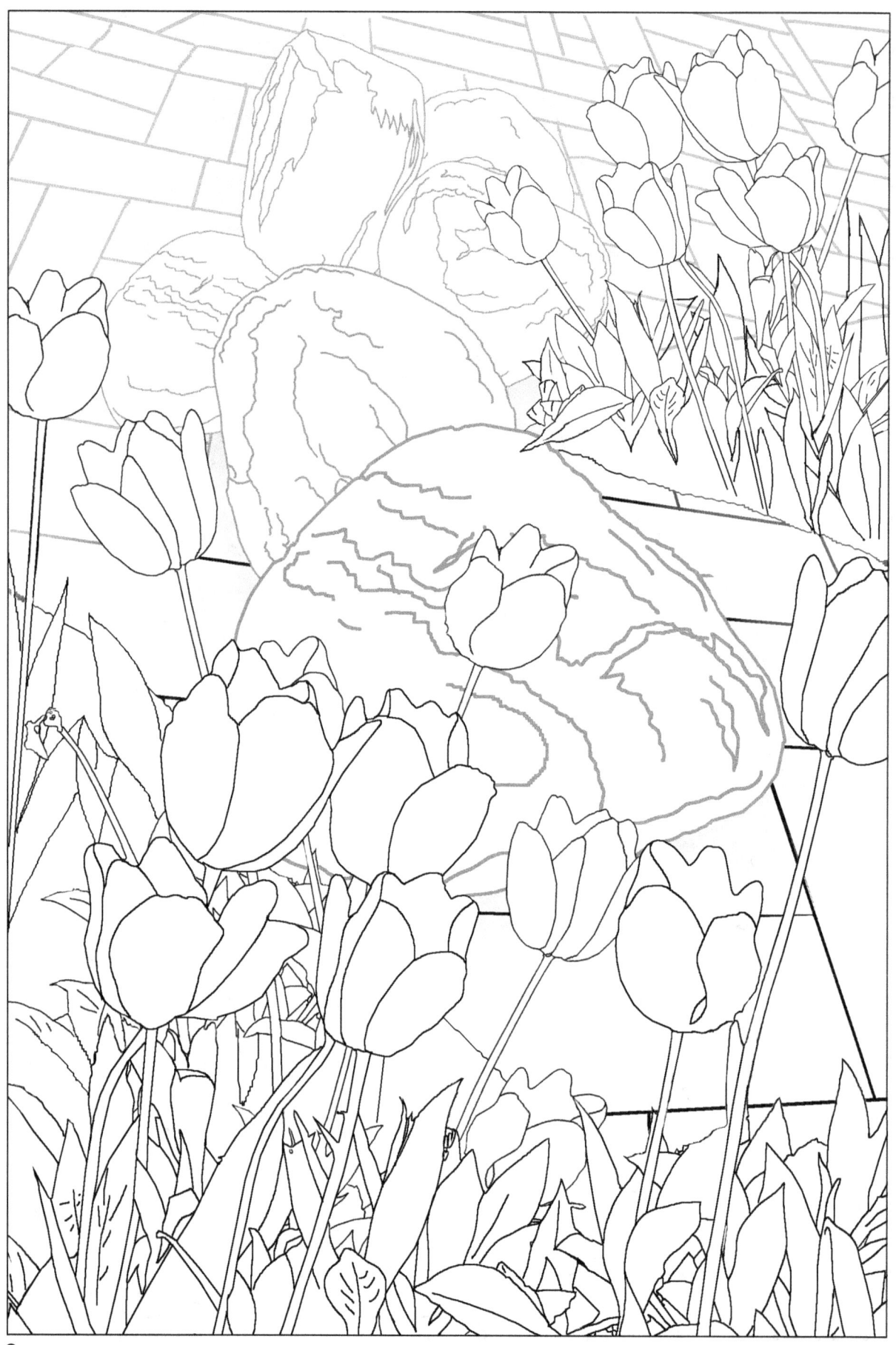

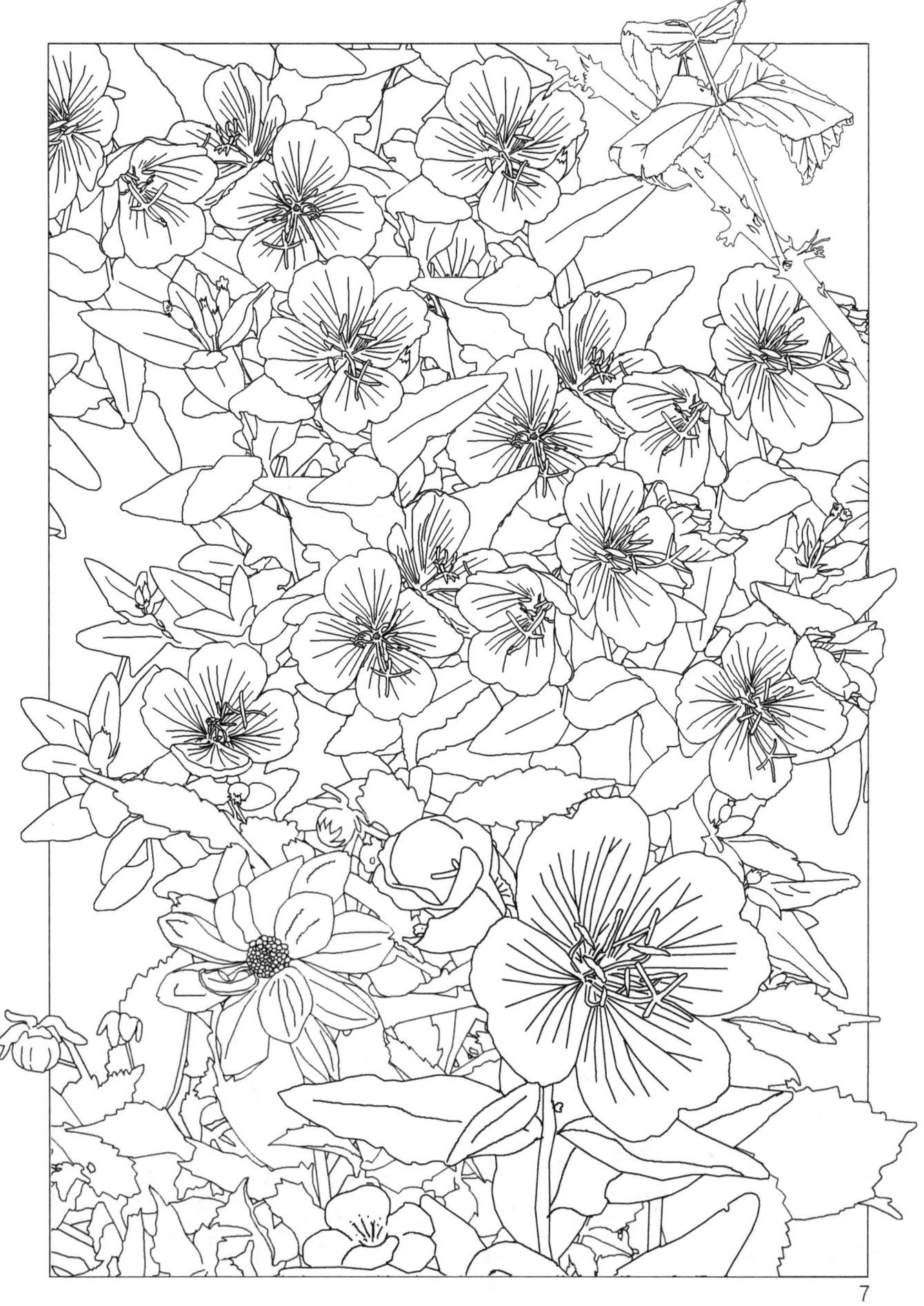

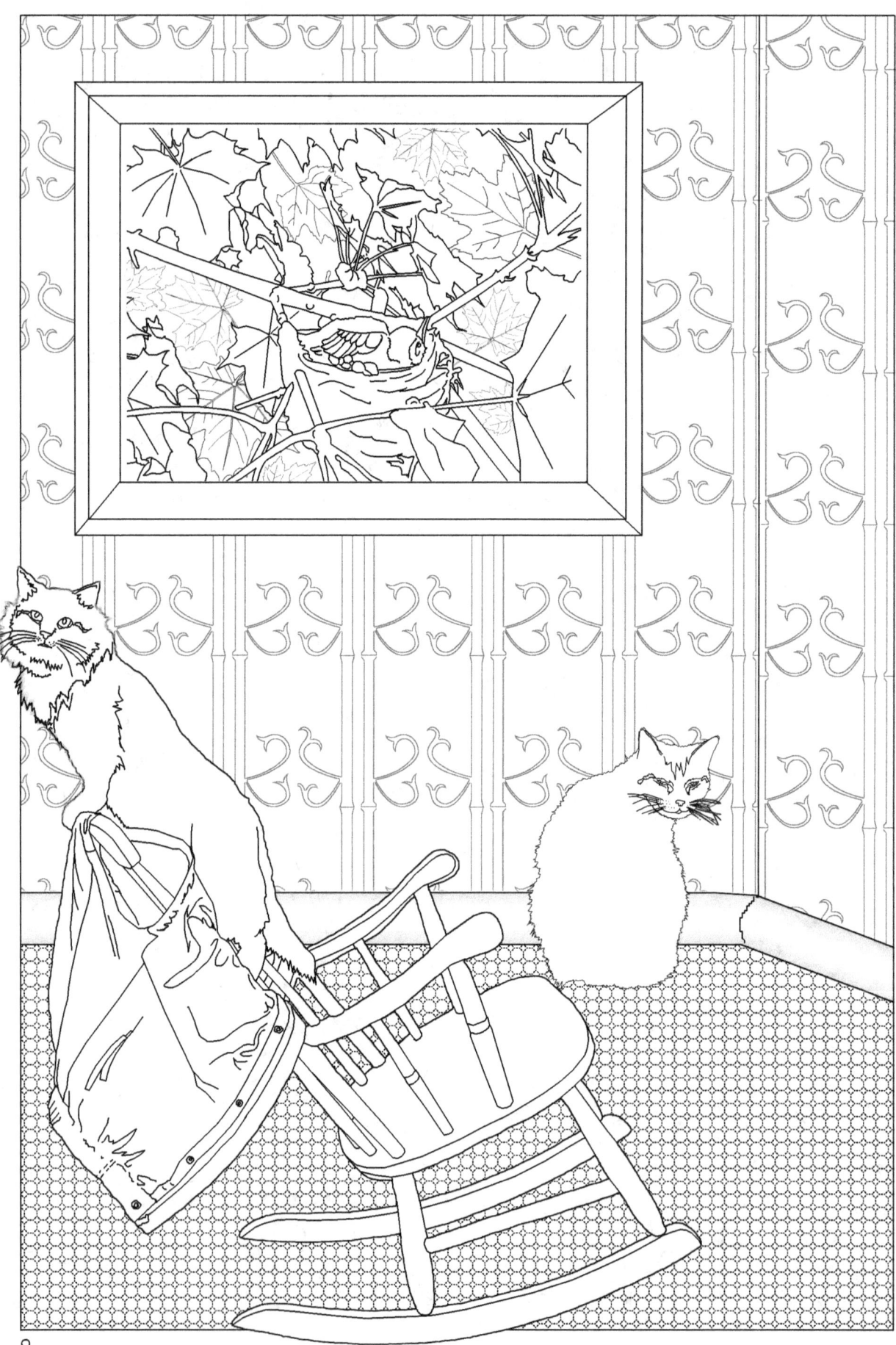

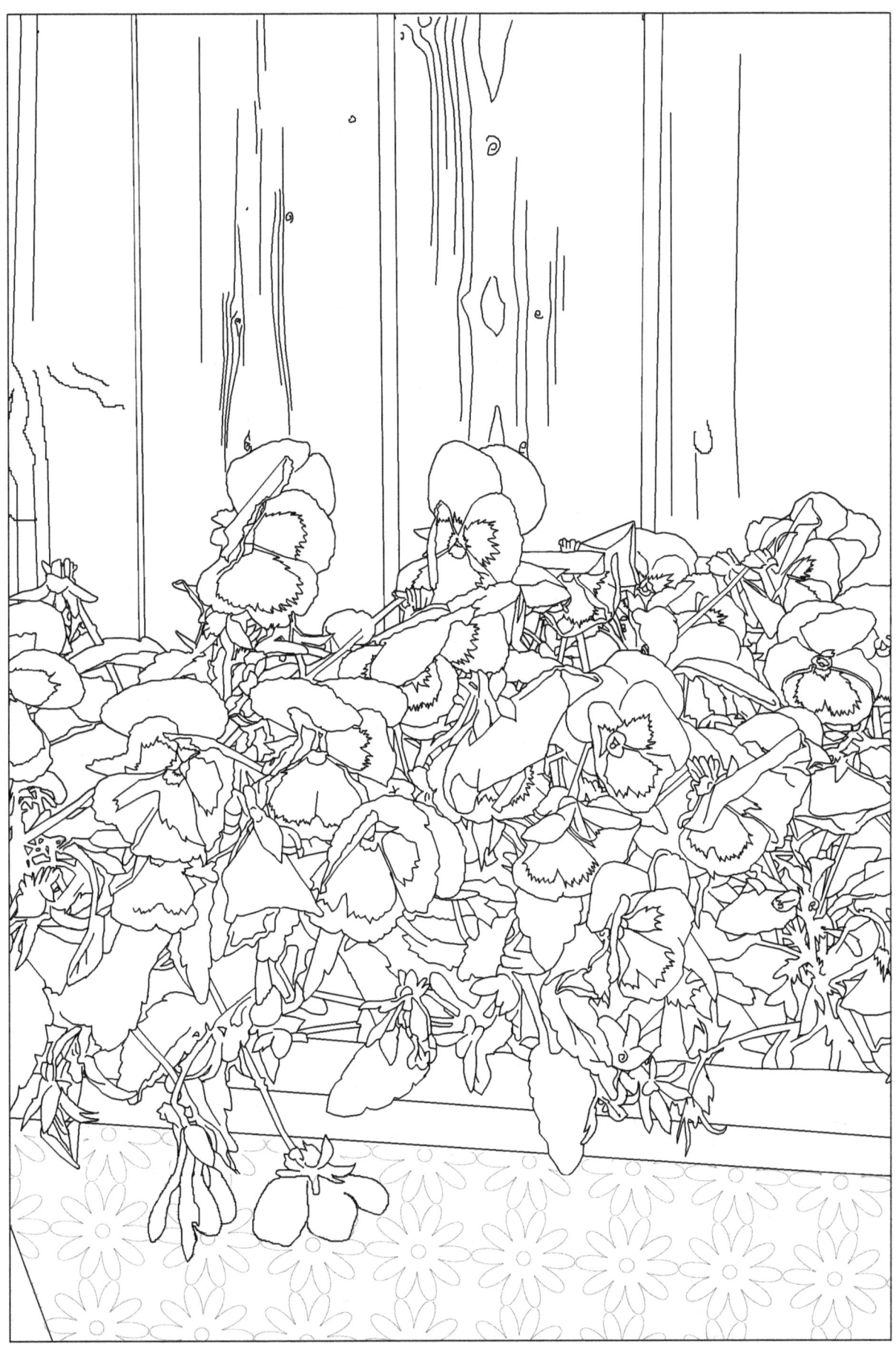

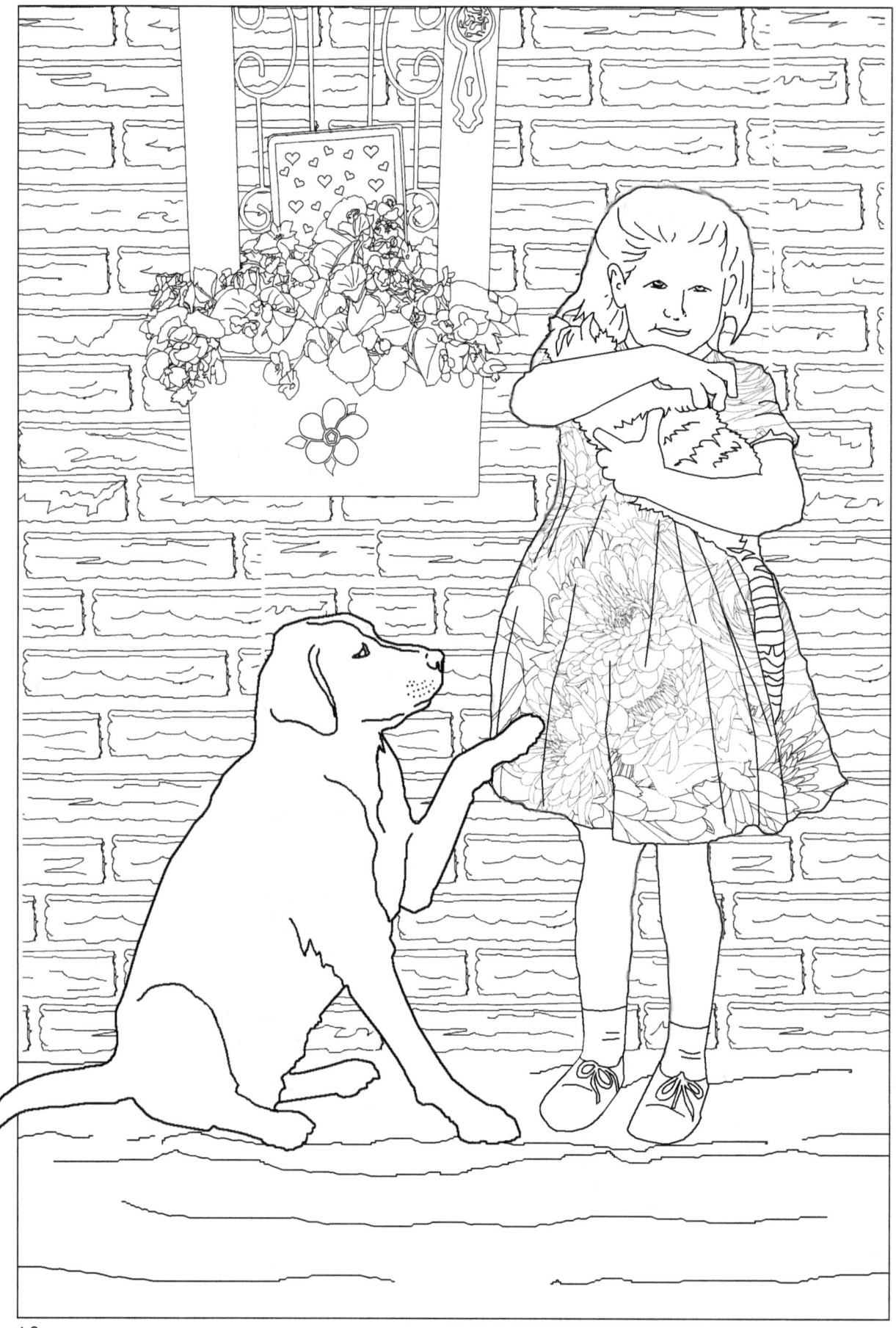

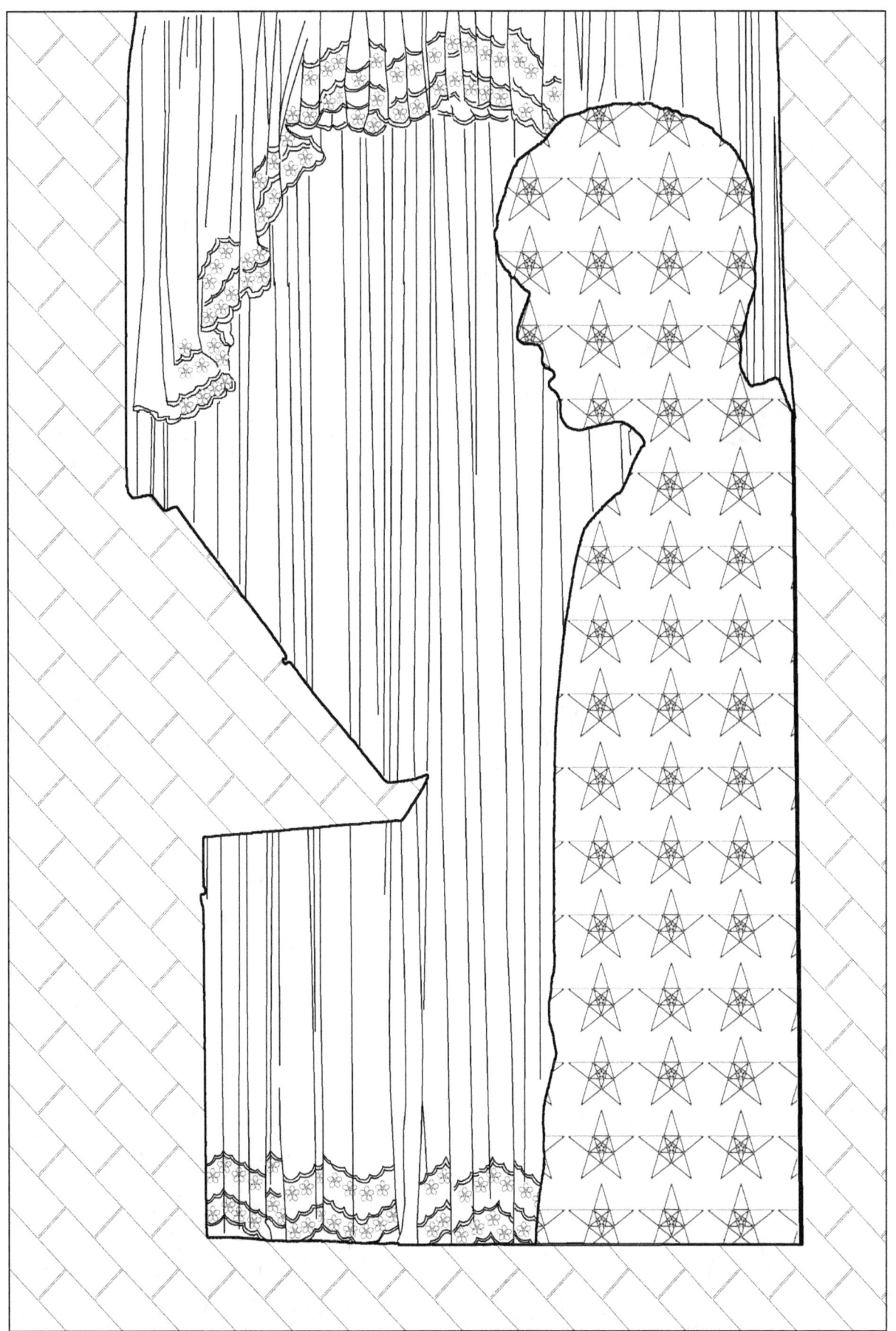

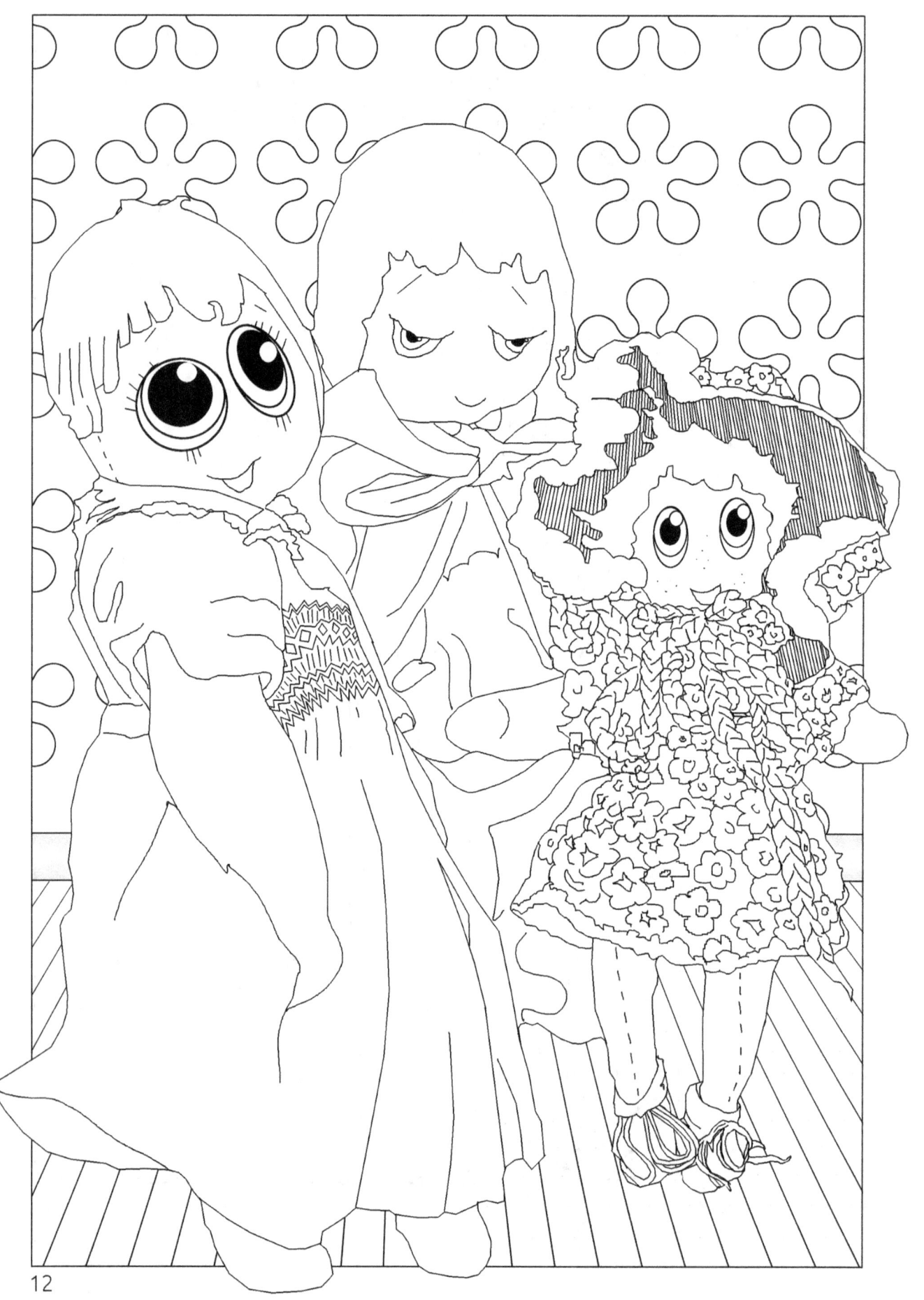

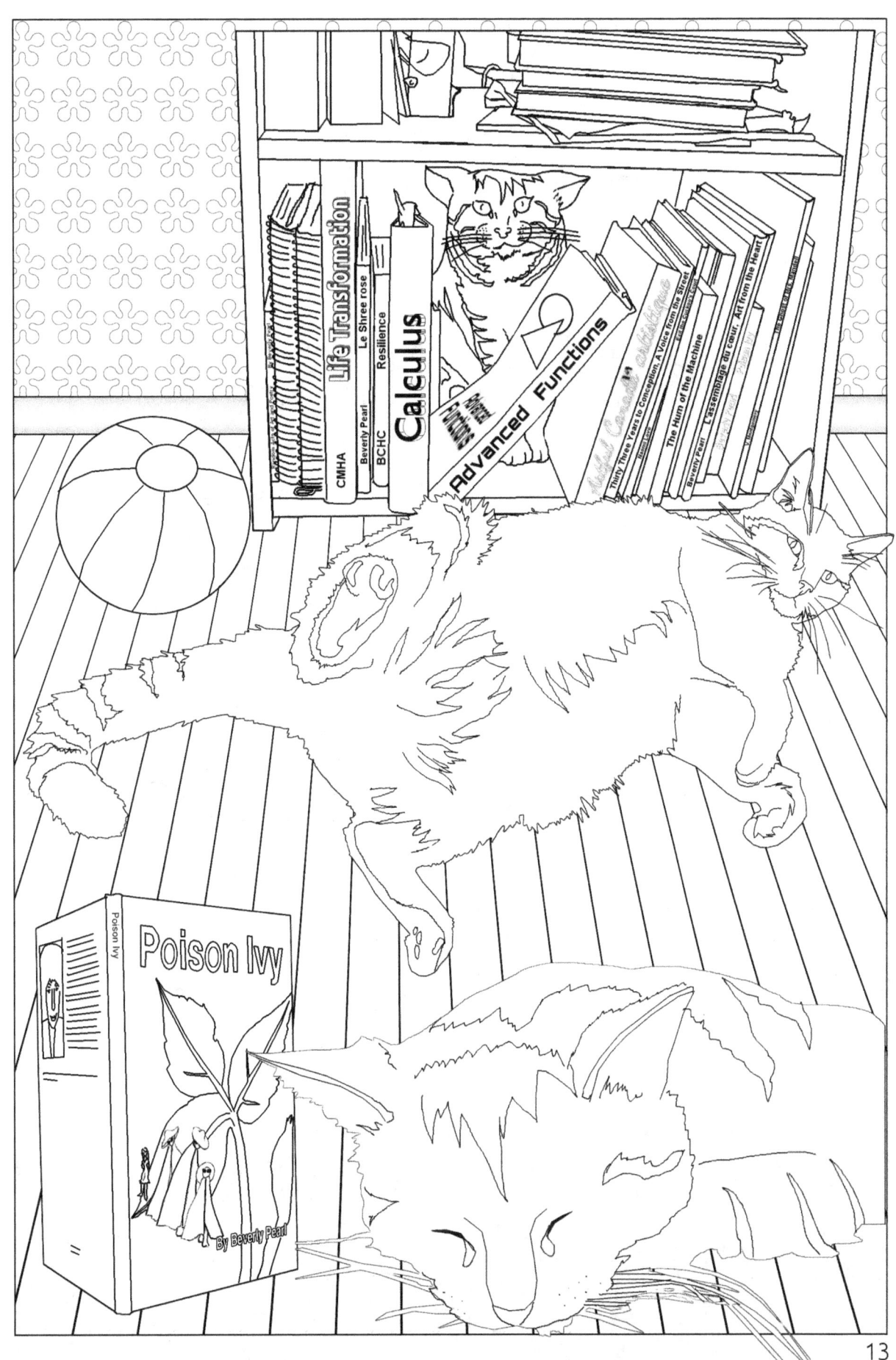

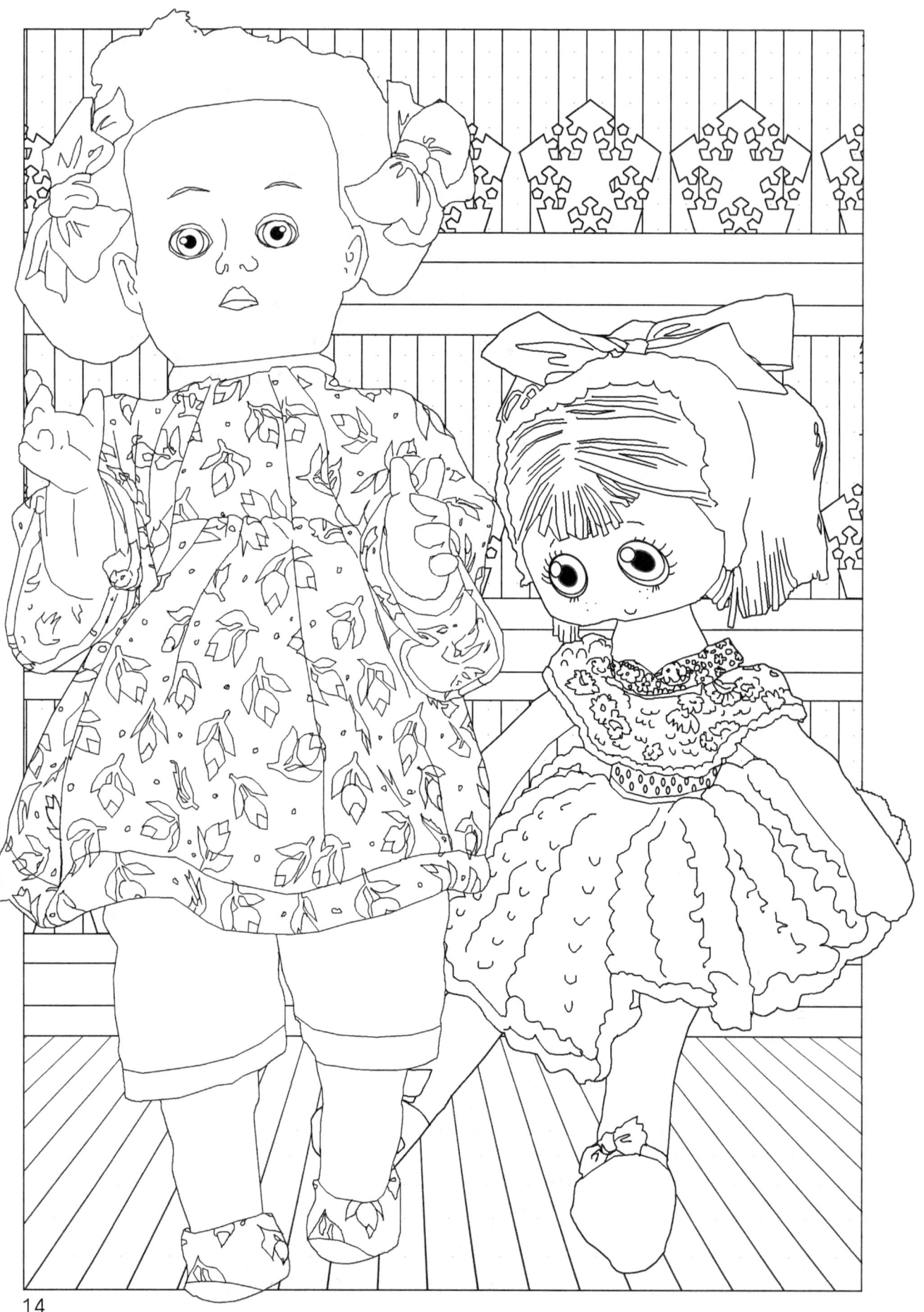

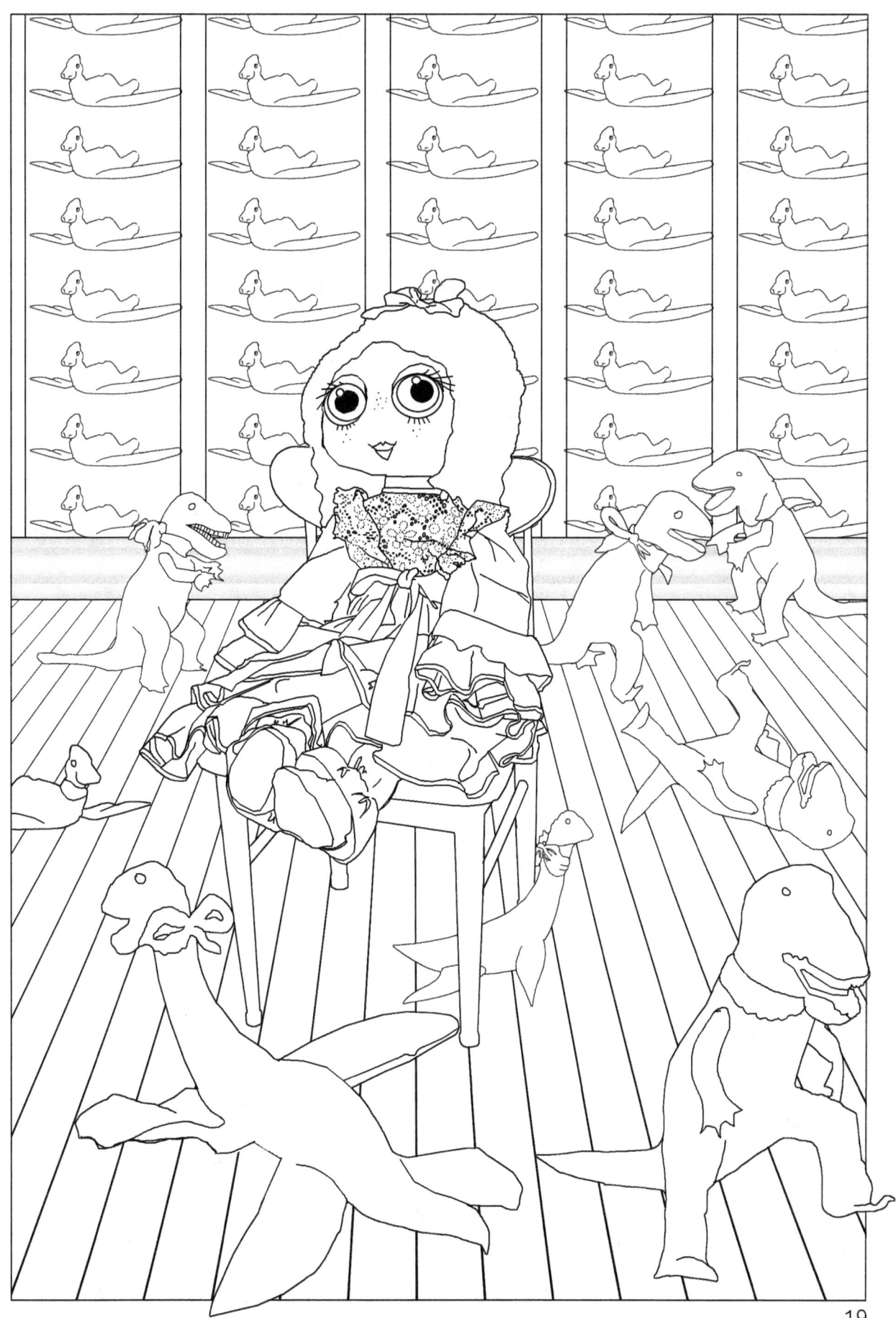

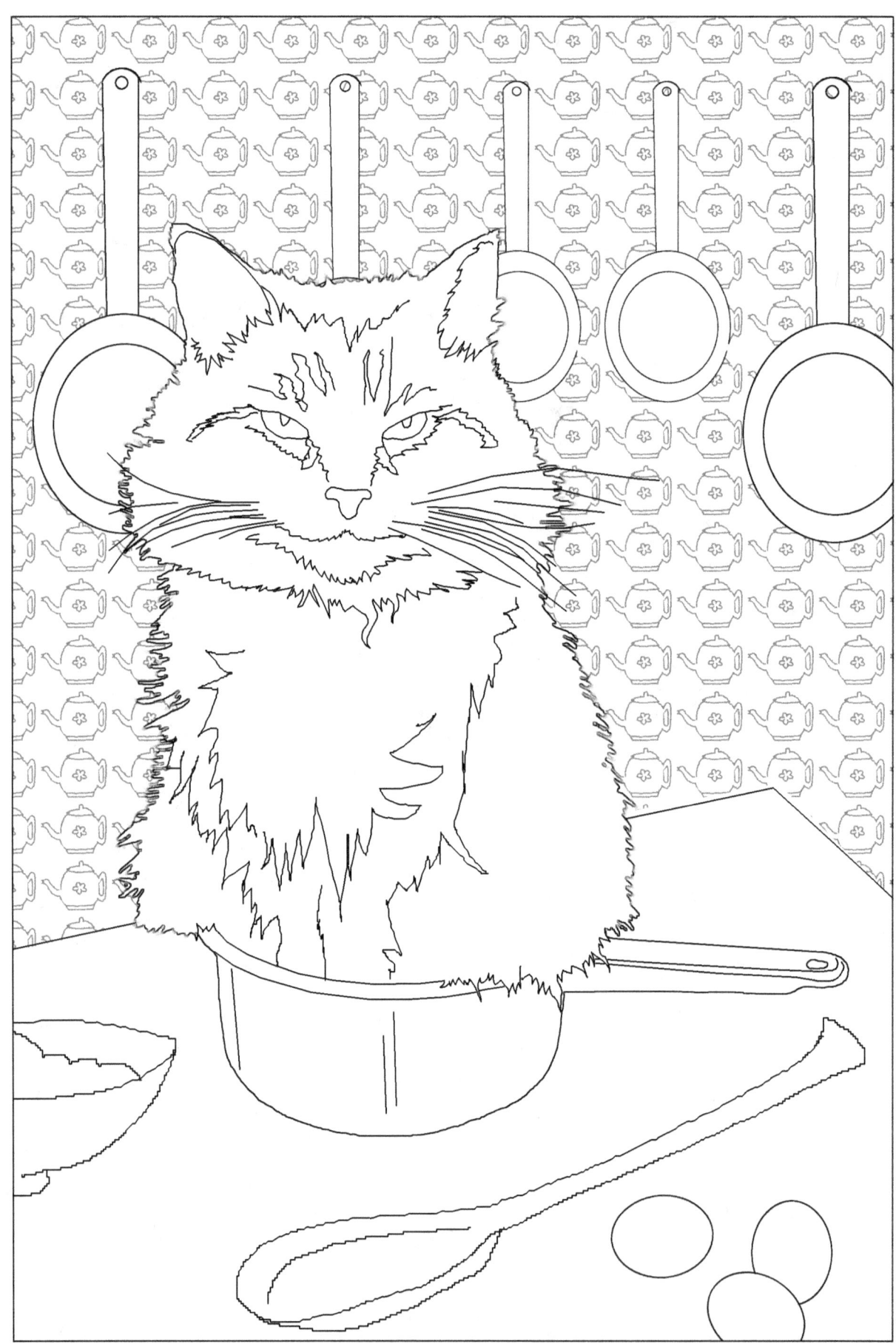

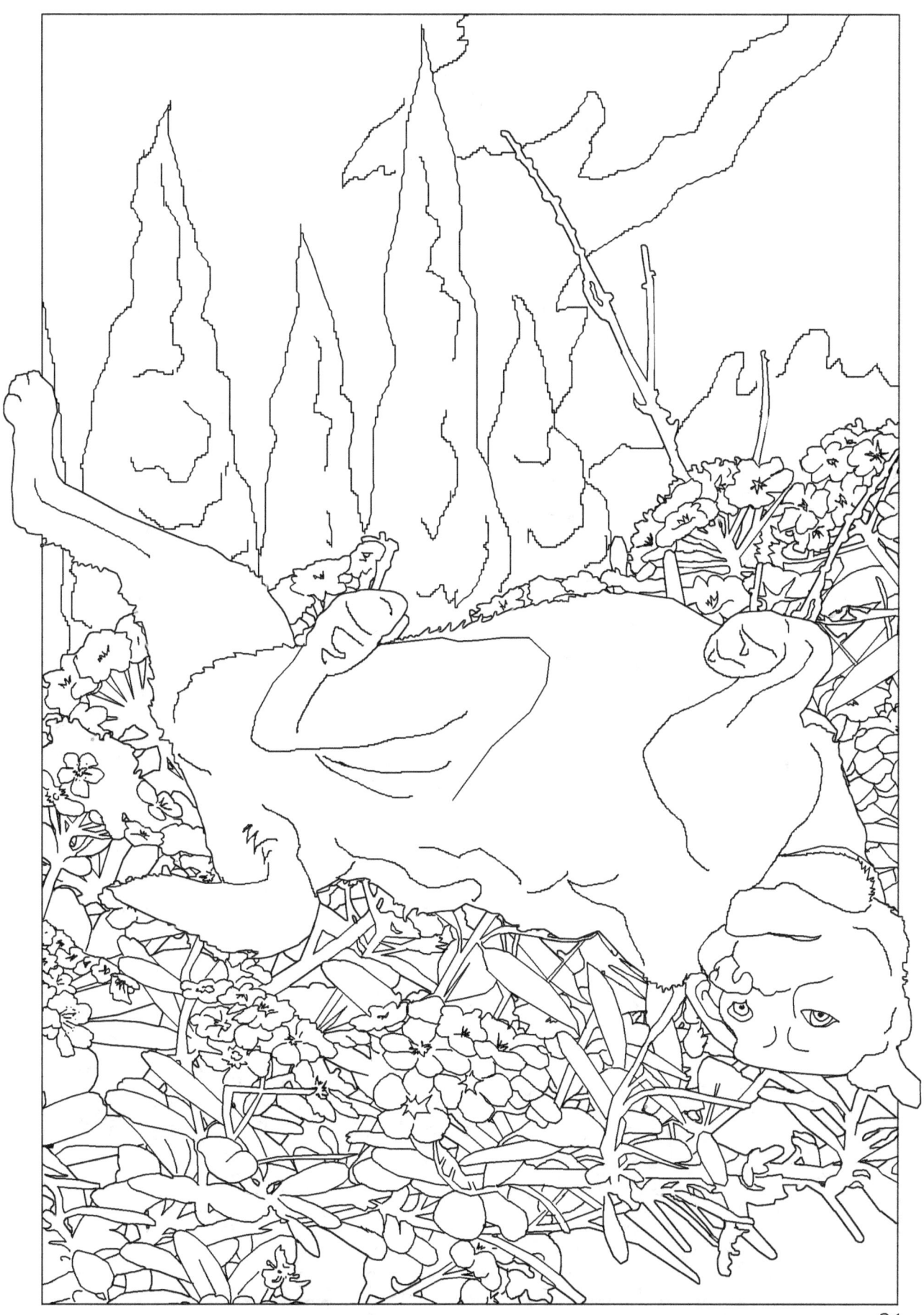

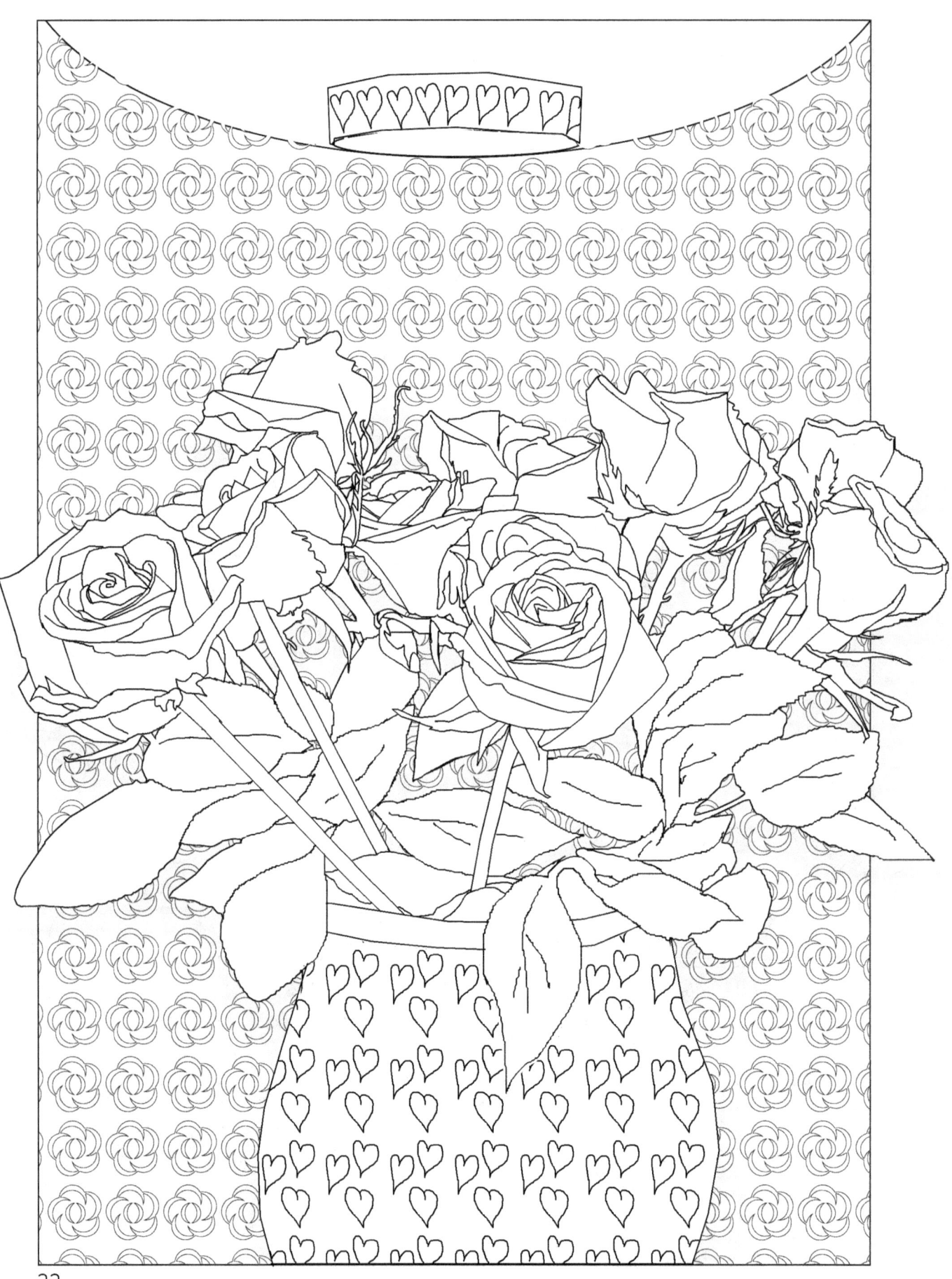

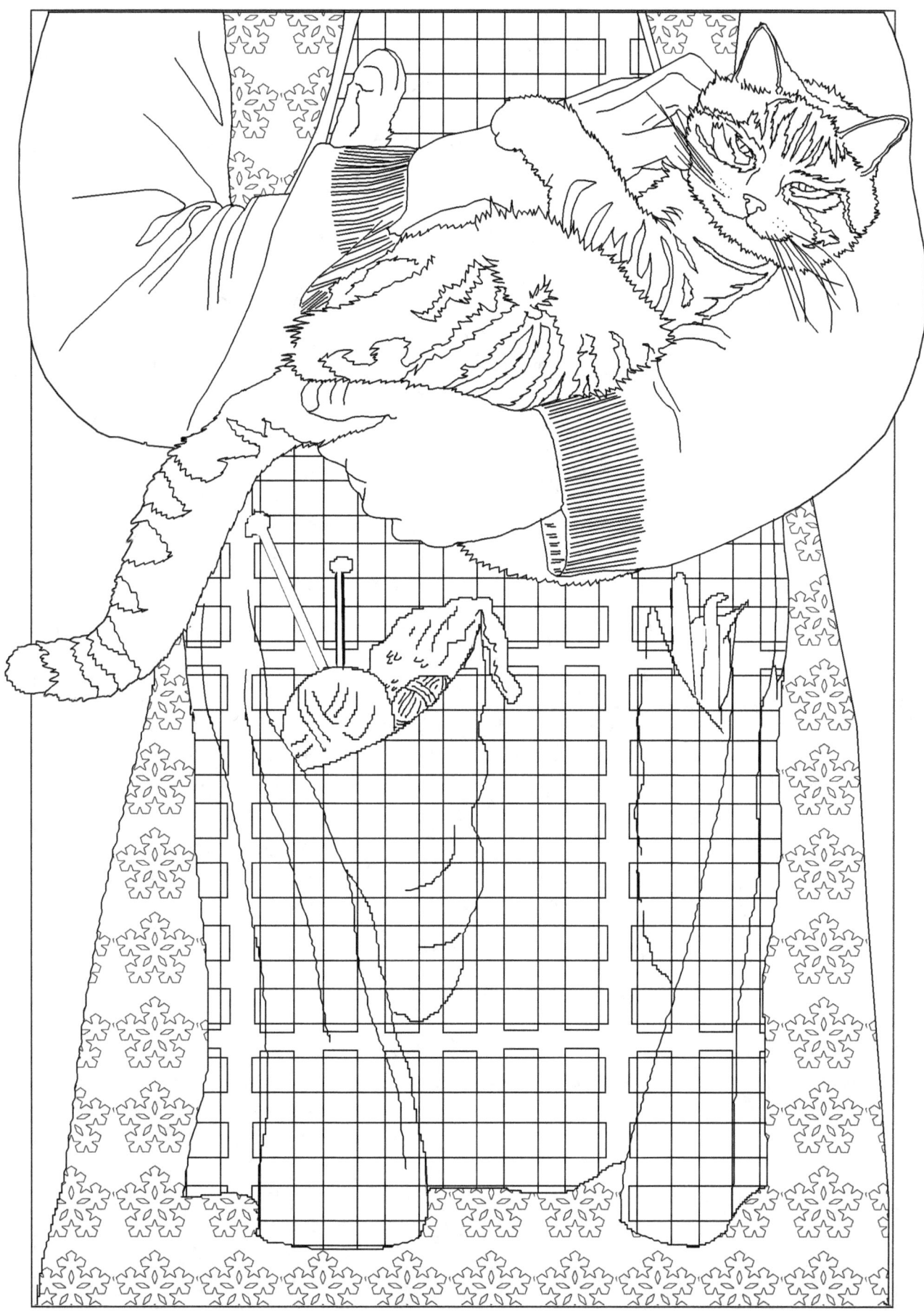

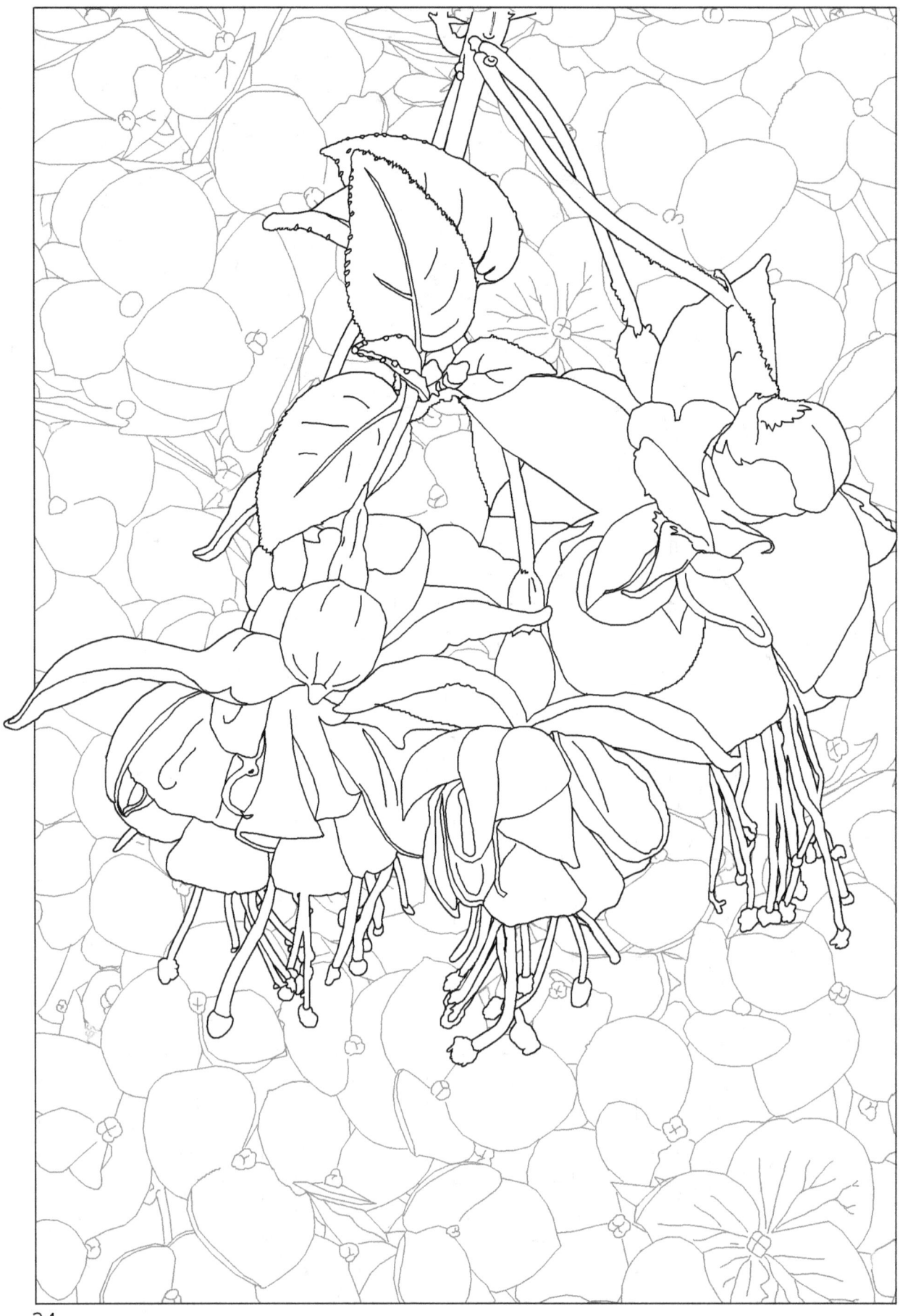

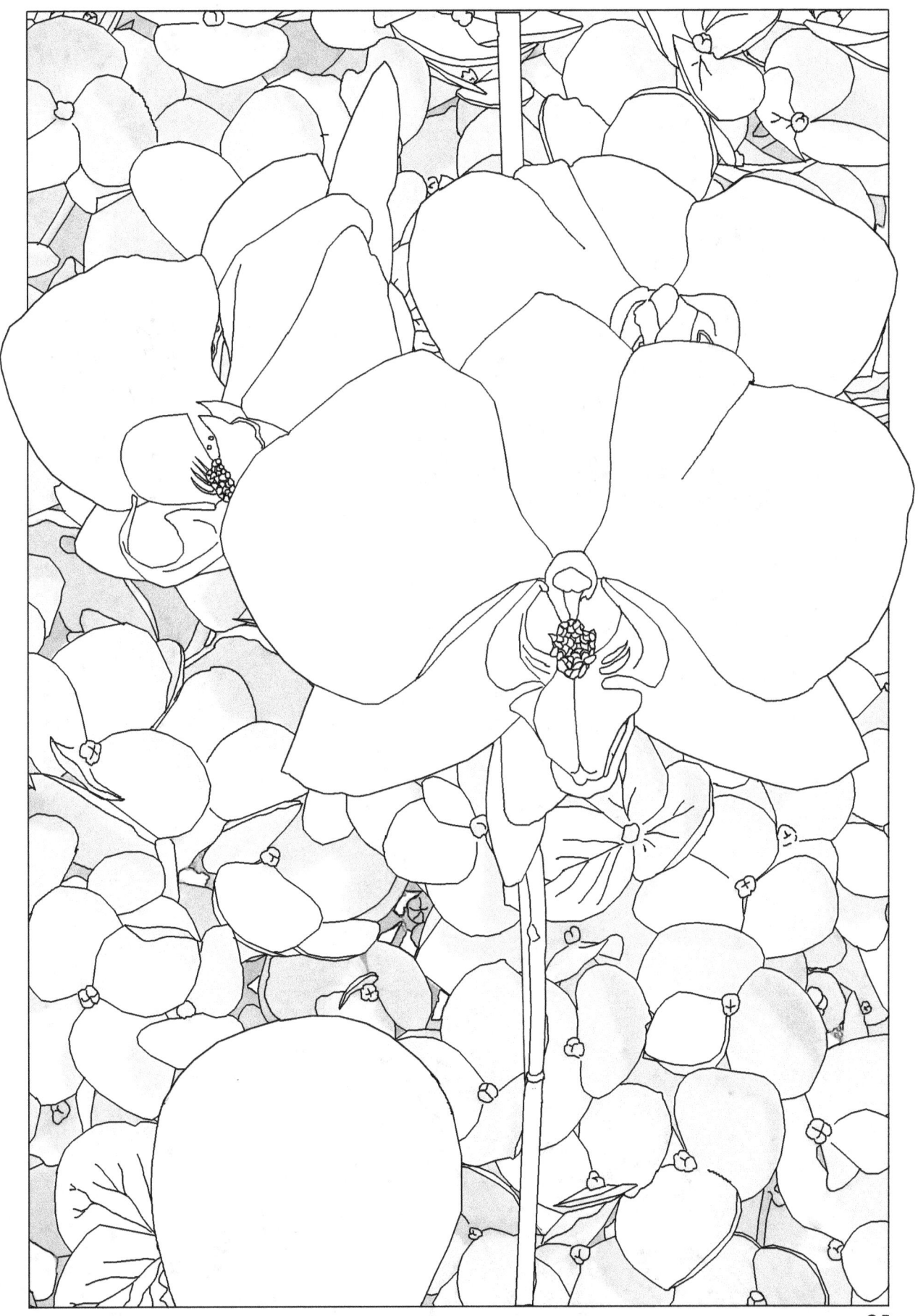

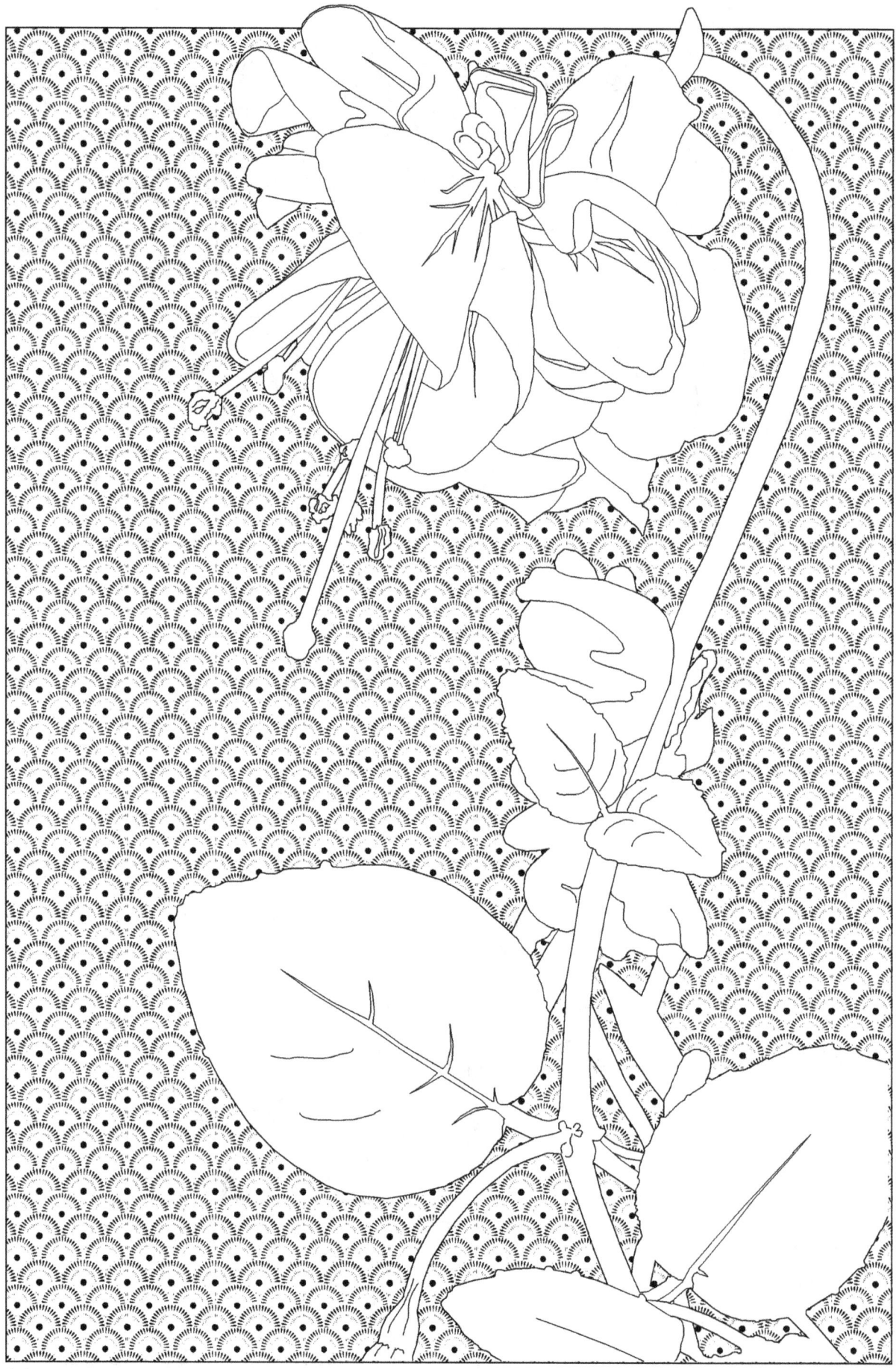

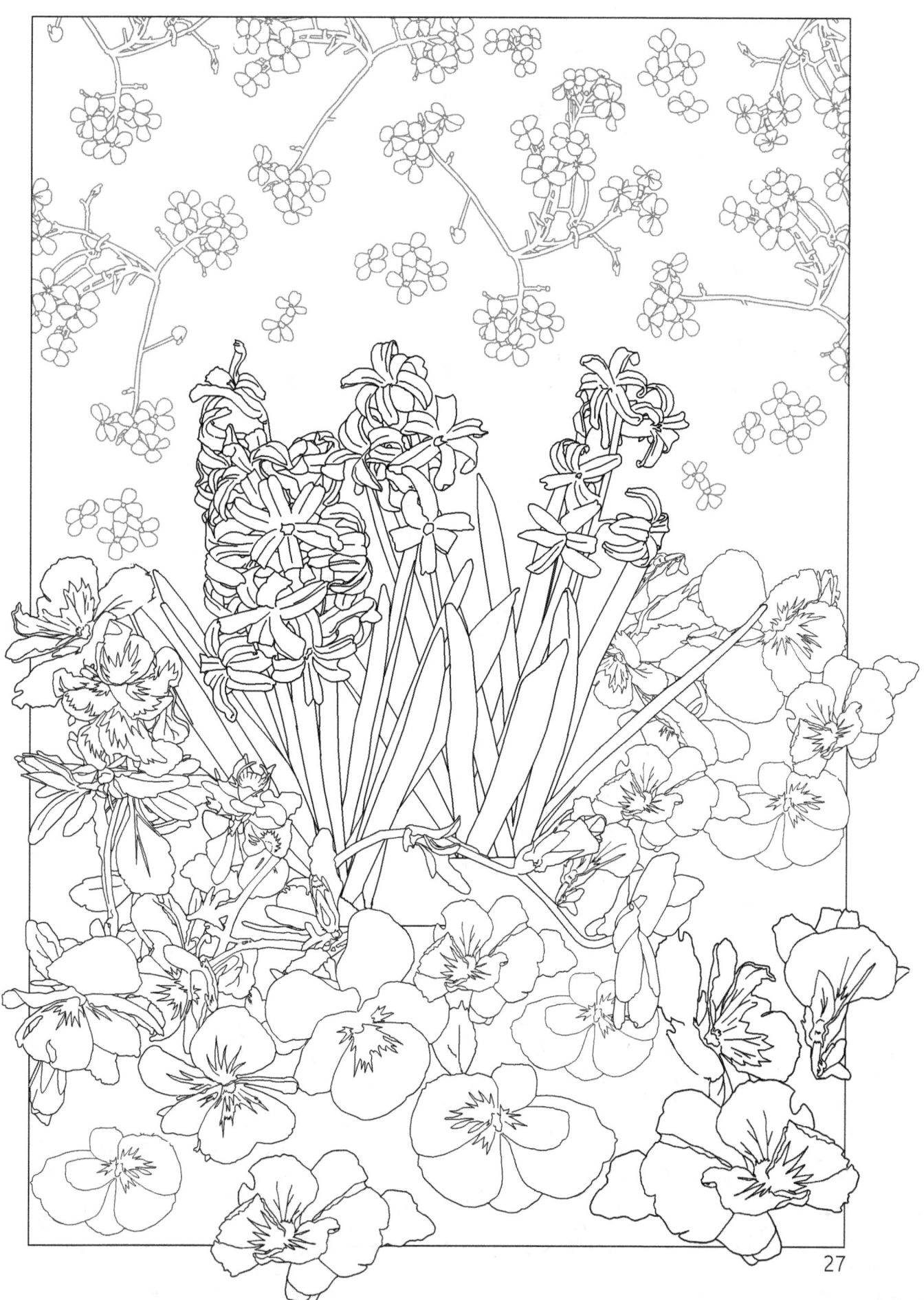

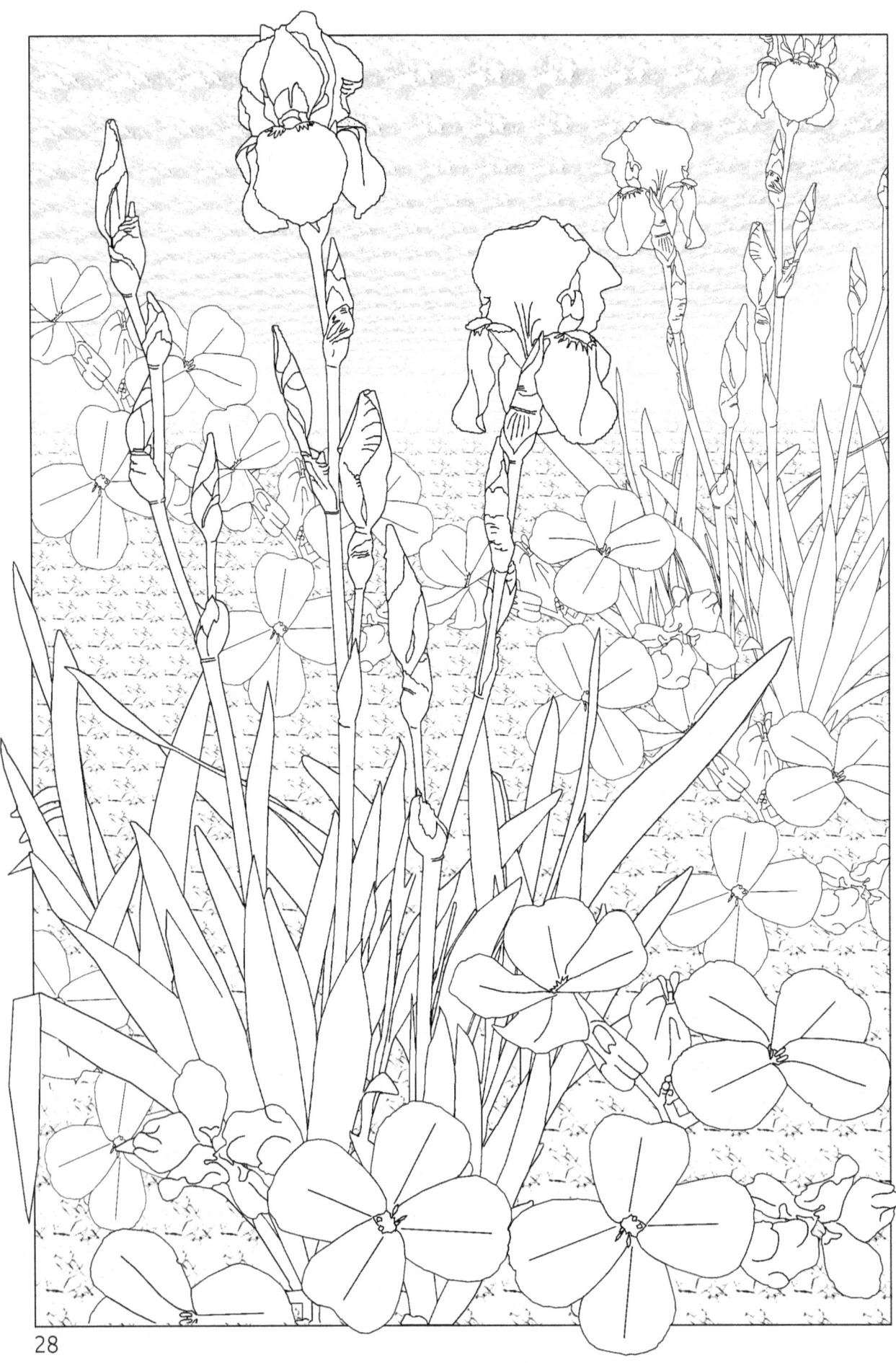

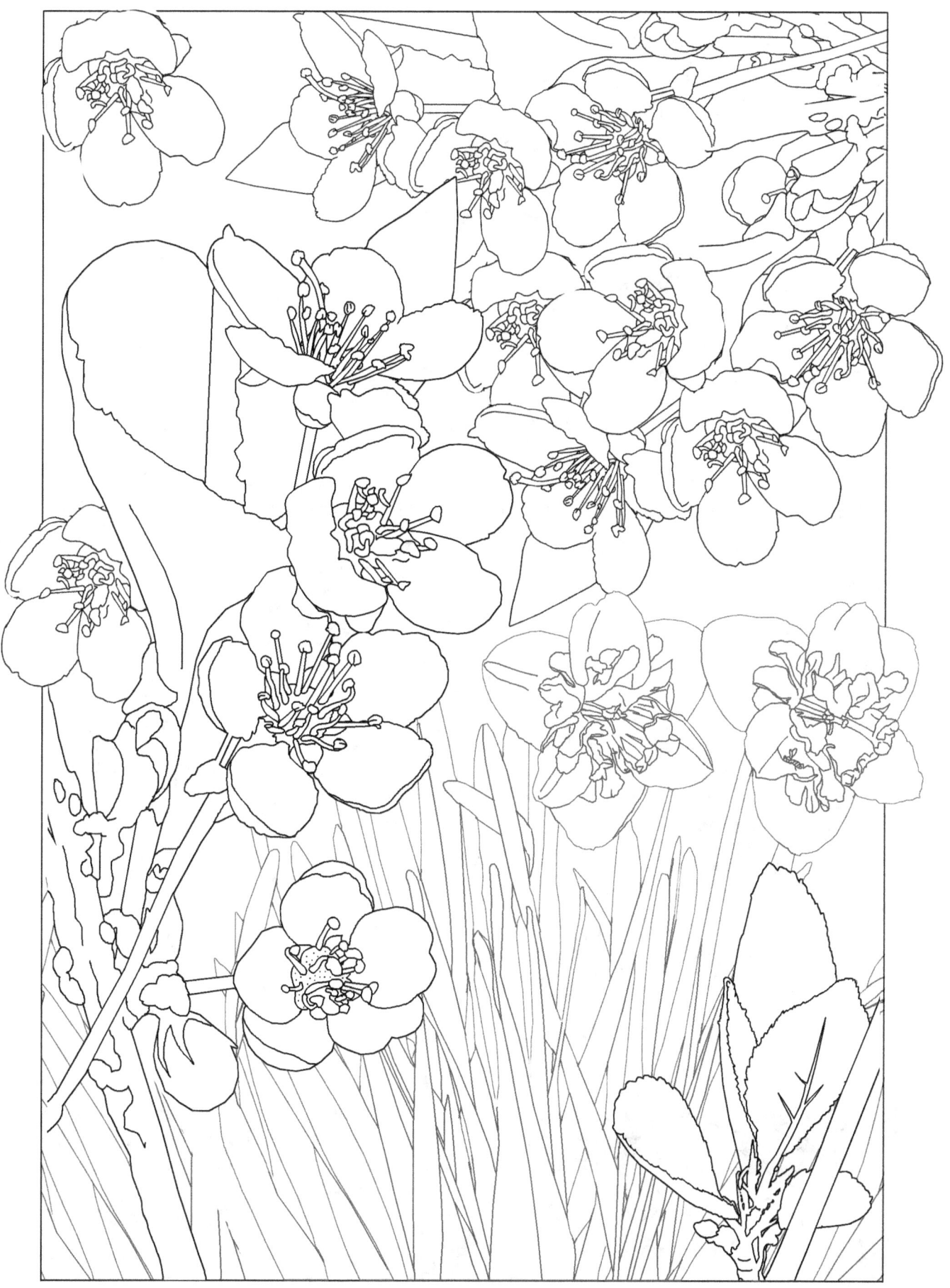

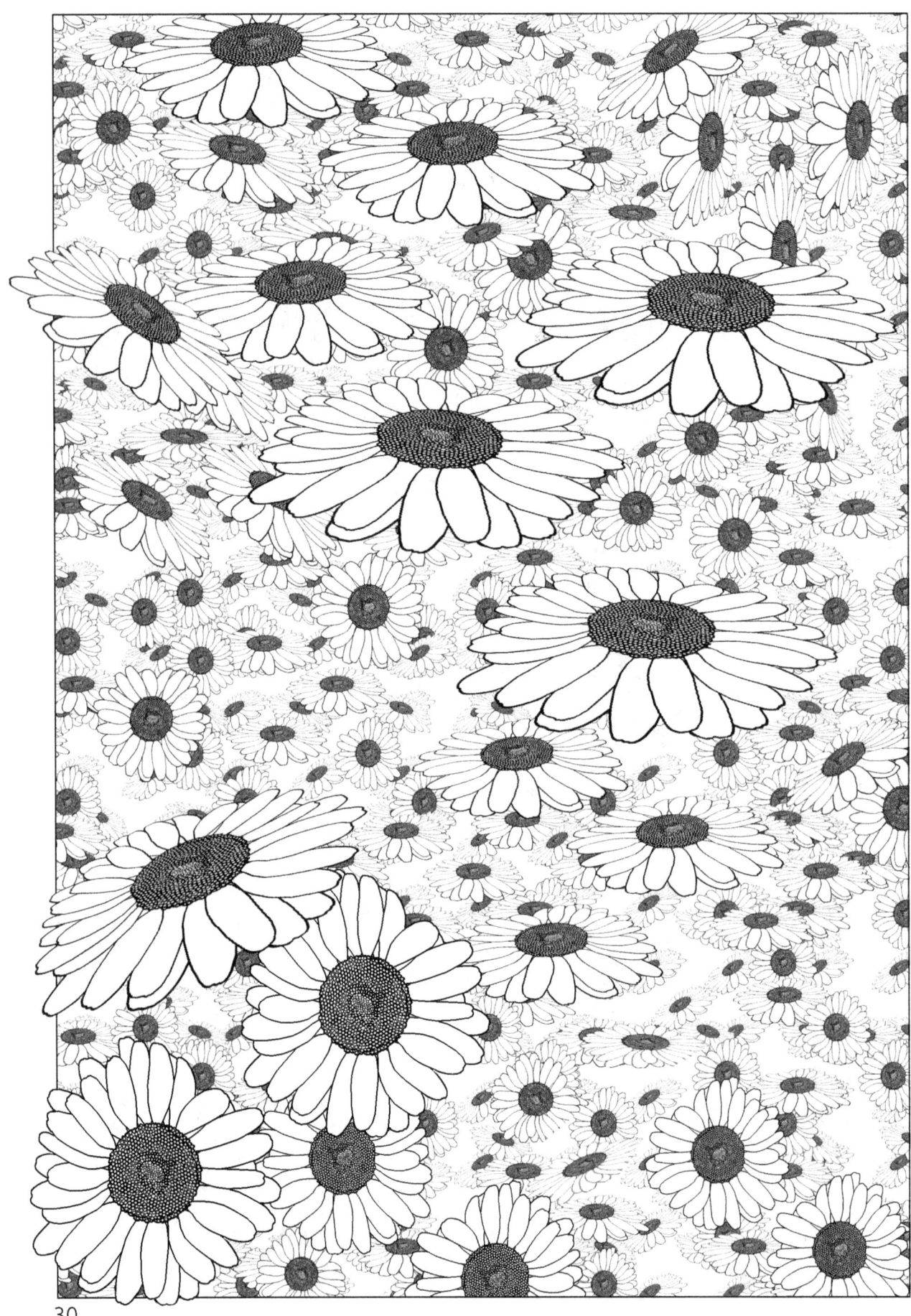

www.ingramcontent.com/pod-product-compliance
Lightning Source LLC
Chambersburg PA
CBHW081147170526
45158CB00009BA/2737